D1577170

Contents

First English language edition 1972
Made and printed in the Netherlands
by Stadler & Sauerbier, Rotterdam
for the publishers B. T. Batsford Ltd
4 Fitzhardinge Street, London W. 1

© Otto Maier Verlag, Ravensburg, 1971
English text © B. T. Batsford Ltd, 1972

ISBN 0 7134 2305 6

Children's paintings are always fascinating. They give enjoyment not only to the children themselves and to their parents, but also to the average adult and, in particular, to anyone concerned with education.

The spontaneity with which the paintings are produced provides an immediate communication between child and spectator, regardless of language.

The techniques used are all very simple and in most cases are self-evident. The text is therefore kept to a minimum. The paintings are reproduced simply to give pleasure as well as to illustrate different techniques.

It is interesting how certain symbols appear to be intuitive to the child. Whatever type of house he lives in, a large square enclosing two or four small squares and a rectangle becomes a house with windows and a door. A triangle forms the roof. A sun always has rays and any scenery is completely lacking in perspective.

Children's Book of Painting

LOTHAR KAMPMANN
English text by THELMA M. NYE

B. T. Batsford Ltd London

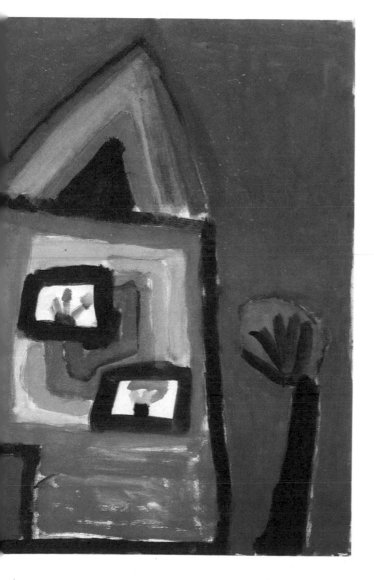

Here is a particularly good example of a house, painted in bright water colours. The symbolic shape is kept but there is the addition of flowers in the windows—maybe window boxes.

By just making splotches a great deal of satisfaction is gained; although not consciously planned, the result is often most attractive.

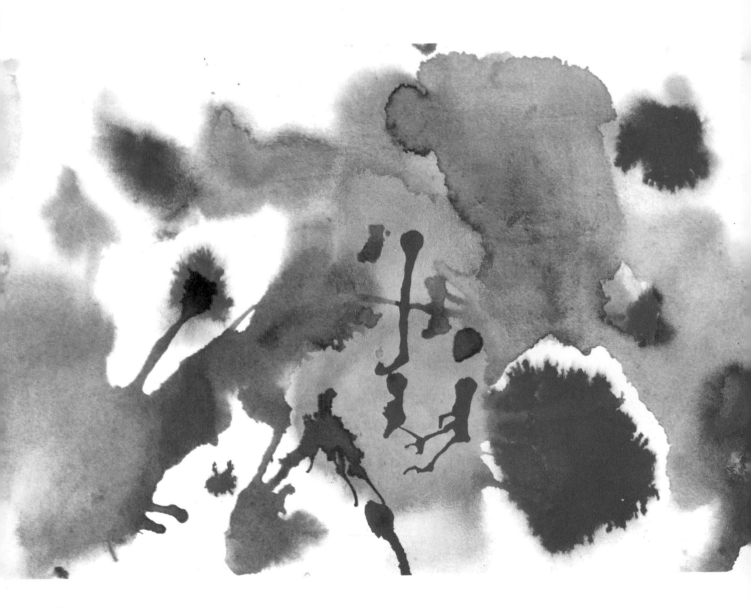

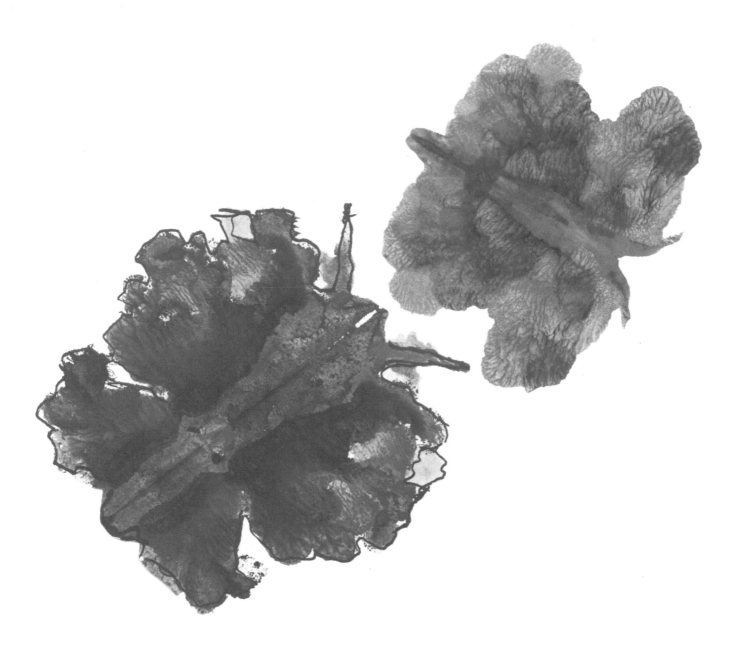

Inkblots

Inkblots never fail to intrigue children. By dropping a blob of paint on to a piece of paper, then folding the paper and pressing it, when it is opened there is always an unexpected and exciting result. While attractive in its own right the inkblot (or paintblot) can be a valuable source of design.

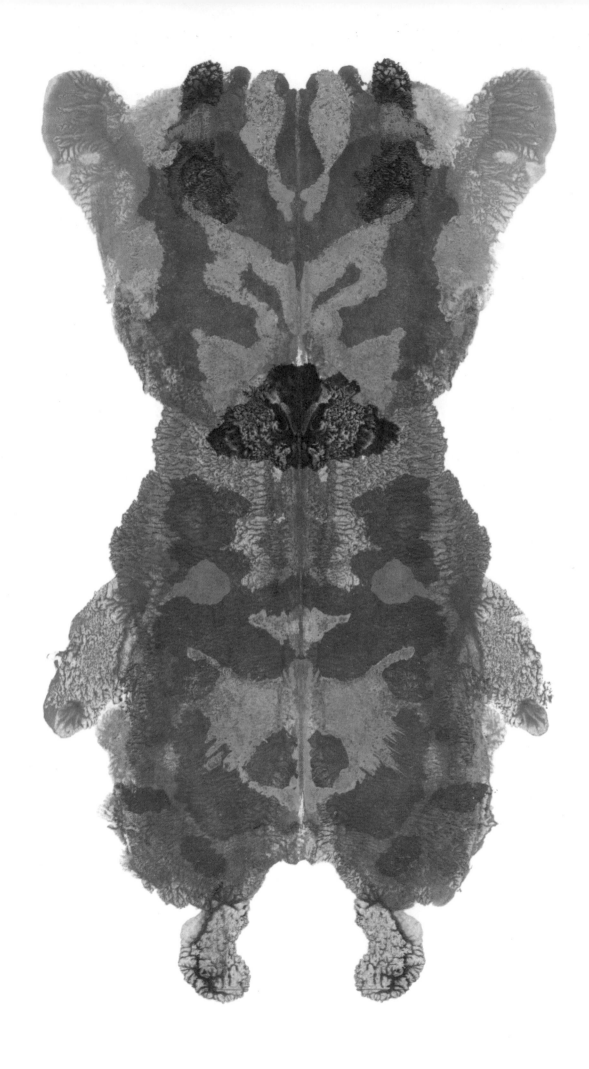

8

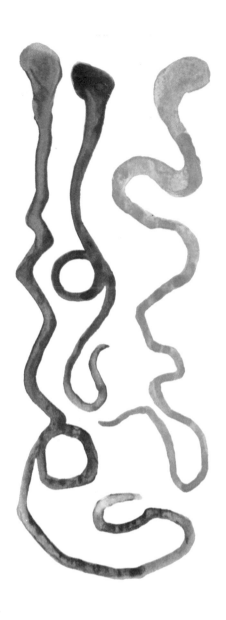

Paint drops
Experiments can be carried out by letting large drops of paint fall on a piece of paper and before the paint is dry holding up the paper and allowing the paint to run. By turning the paper all sorts of shapes can be made.

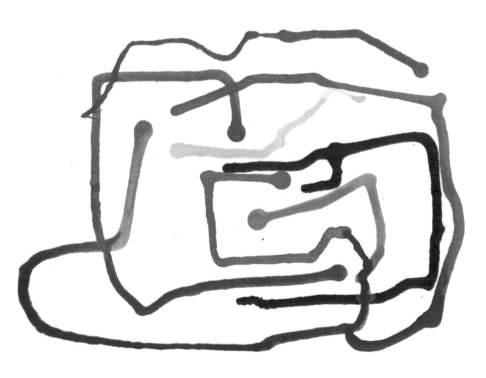

Blow painting

Simply by blowing wet drops of paint across a sheet of paper interesting results are obtained.

By using a straw a much more controlled design can be produced. An ideal method for showing a brightly coloured flower bed and for capturing the quality of fireworks is shown here.

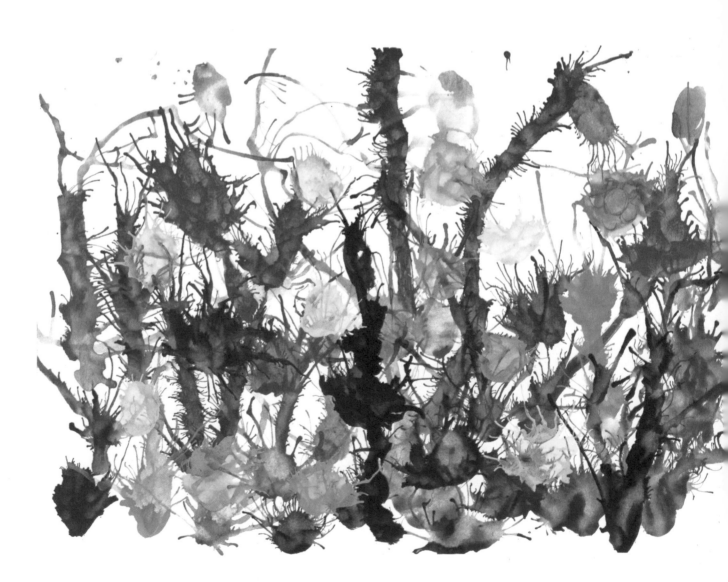

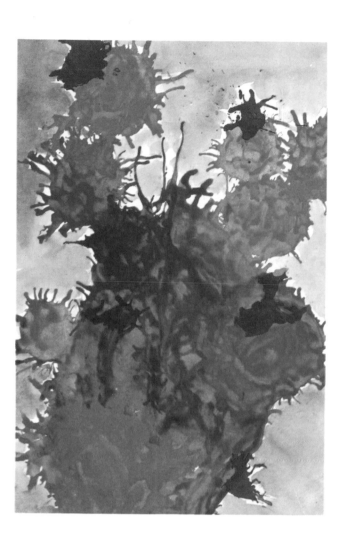

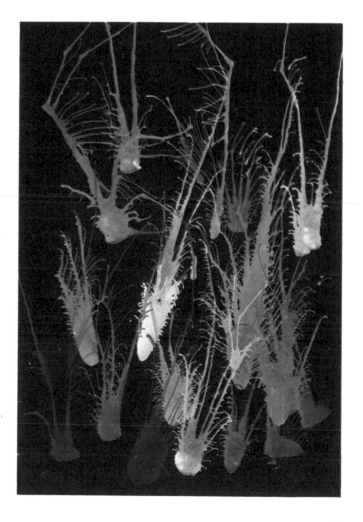

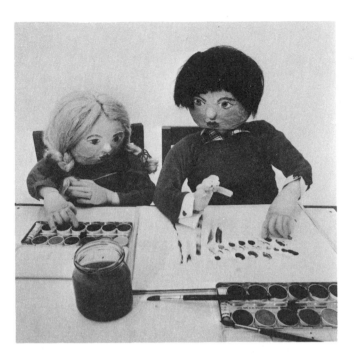

Finger Painting

All children like using their fingers and much enjoyment can be had from dipping fingers into the paint and drawing direct on to paper or a plastic surface. A different colour can be used on every finger! This can be a somewhat 'messy' technique if not carefully supervised.

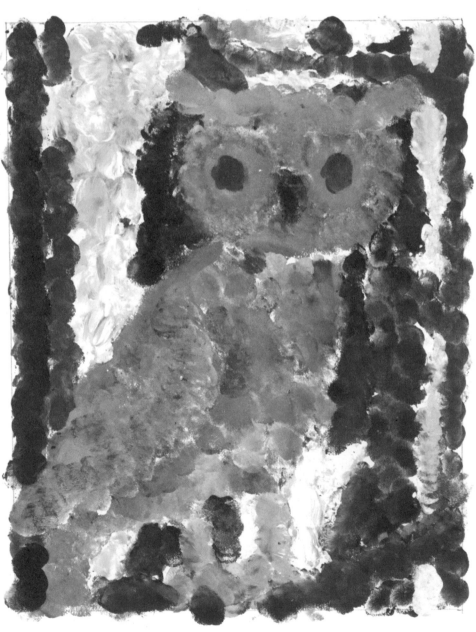

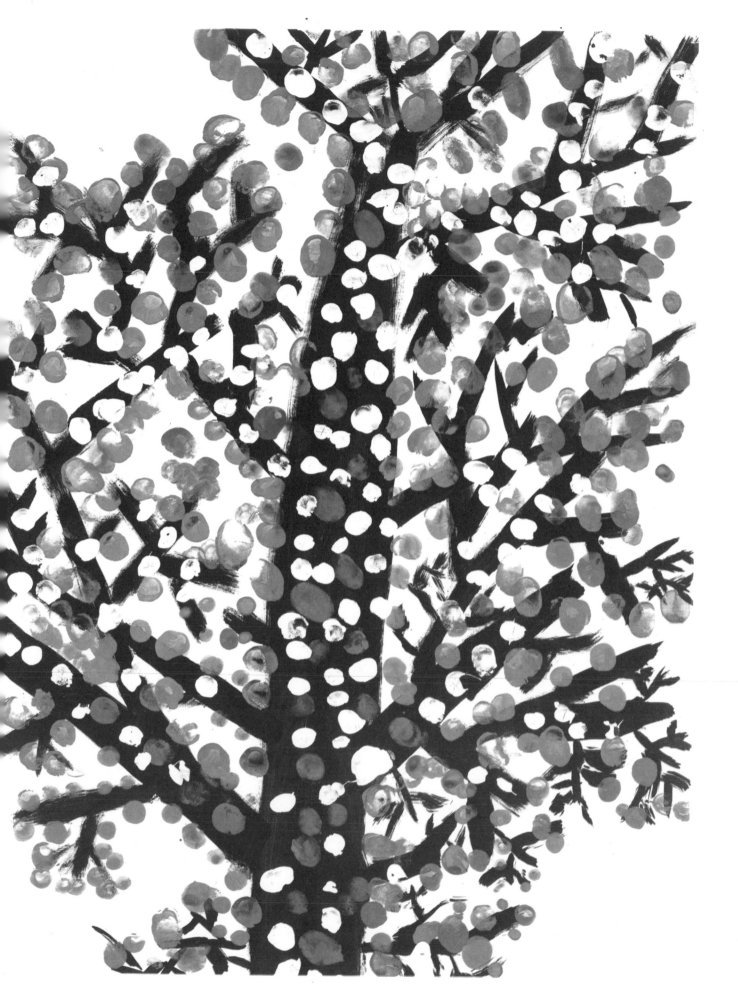

Hand prints
Prints with the whole hand can also produce interesting results as seen here where the repetition of hand prints is made up into the shape of a bird, and a most effective sun.

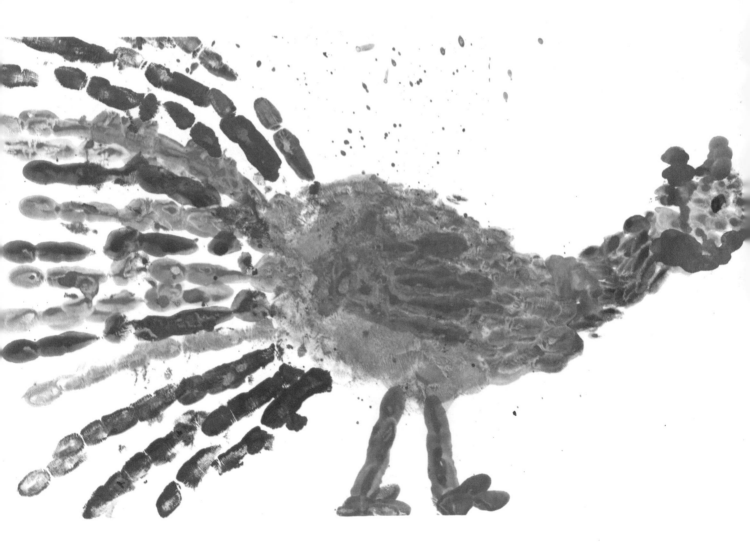

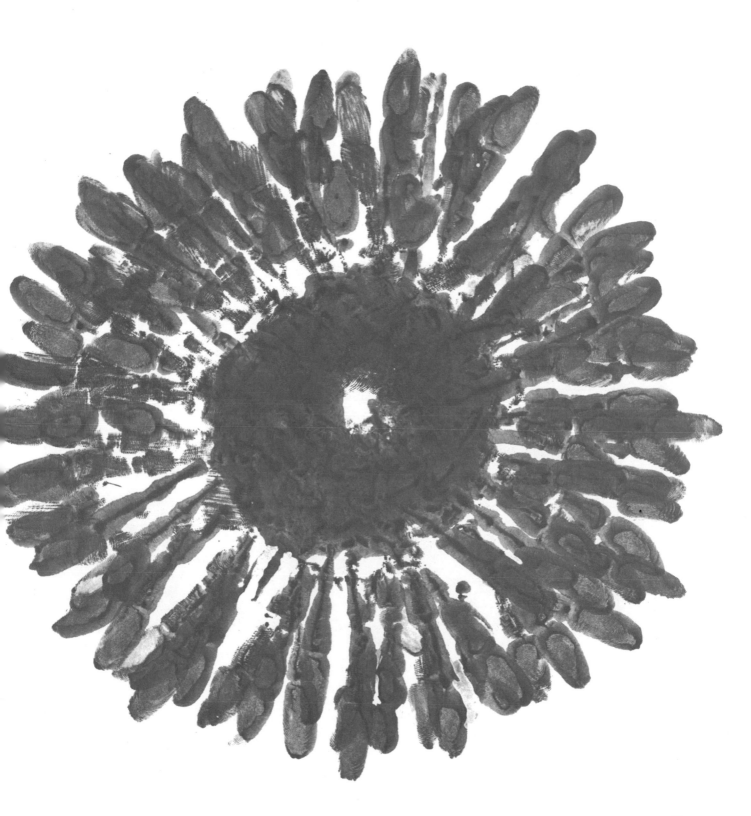

Painting with a rag

Rubbing paint from the hand on to a rag gives an idea for using the rag as a 'tool' for painting. The train and rug pictures are the results of using this technique.

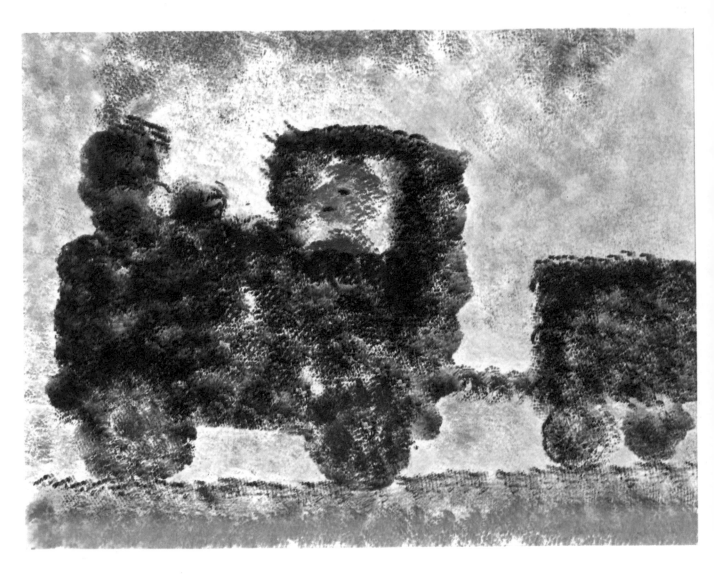

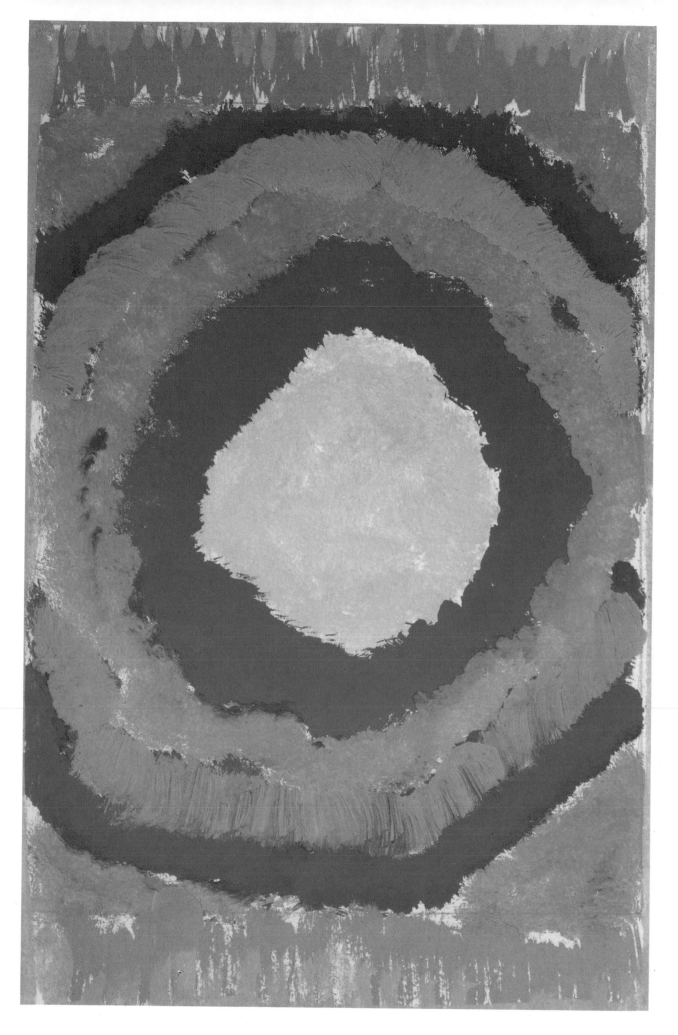

17

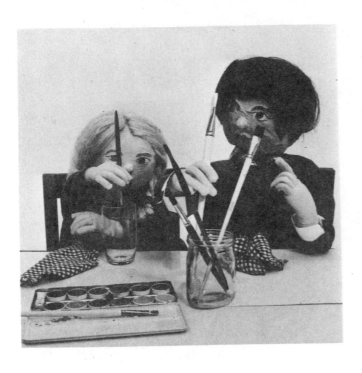

Using a paint brush
Once a child has learned how to co-ordinate his hand and a paint brush he finds he can attempt more intricate work such as the sunflower illustrated opposite.

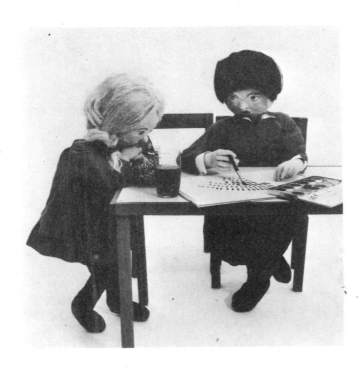

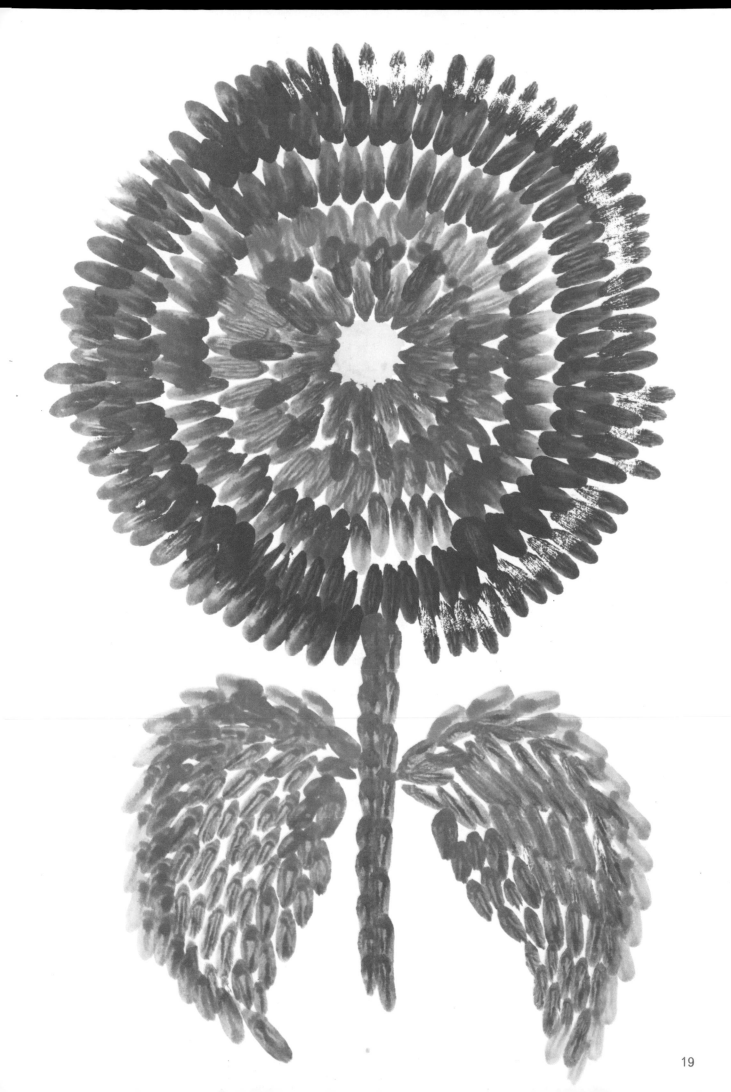

19

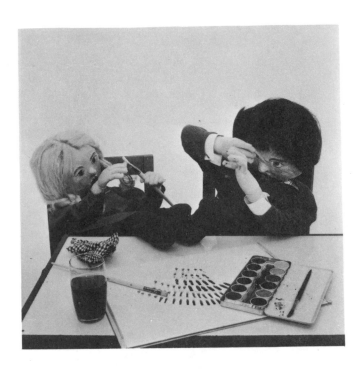

Sprinkle painting

A sprinkled painting is most attractive. This result is attained by rubbing a stiff bristled brush, dipped in paint, through a fine mesh strainer.

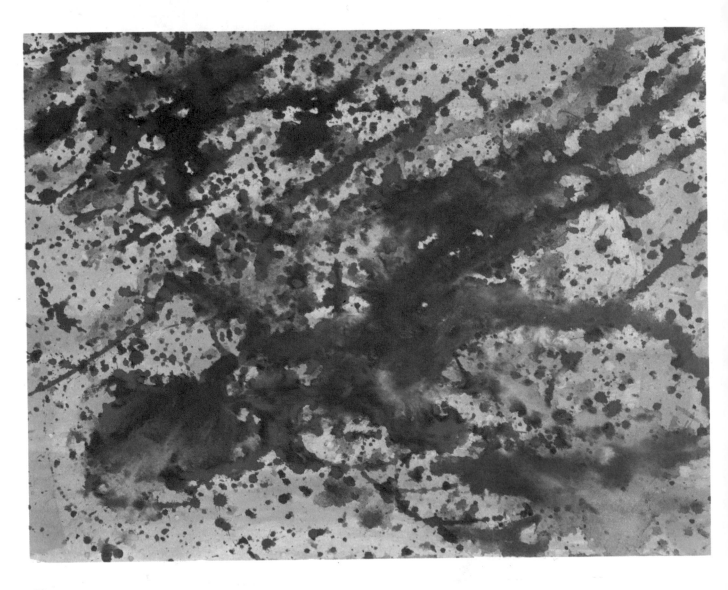

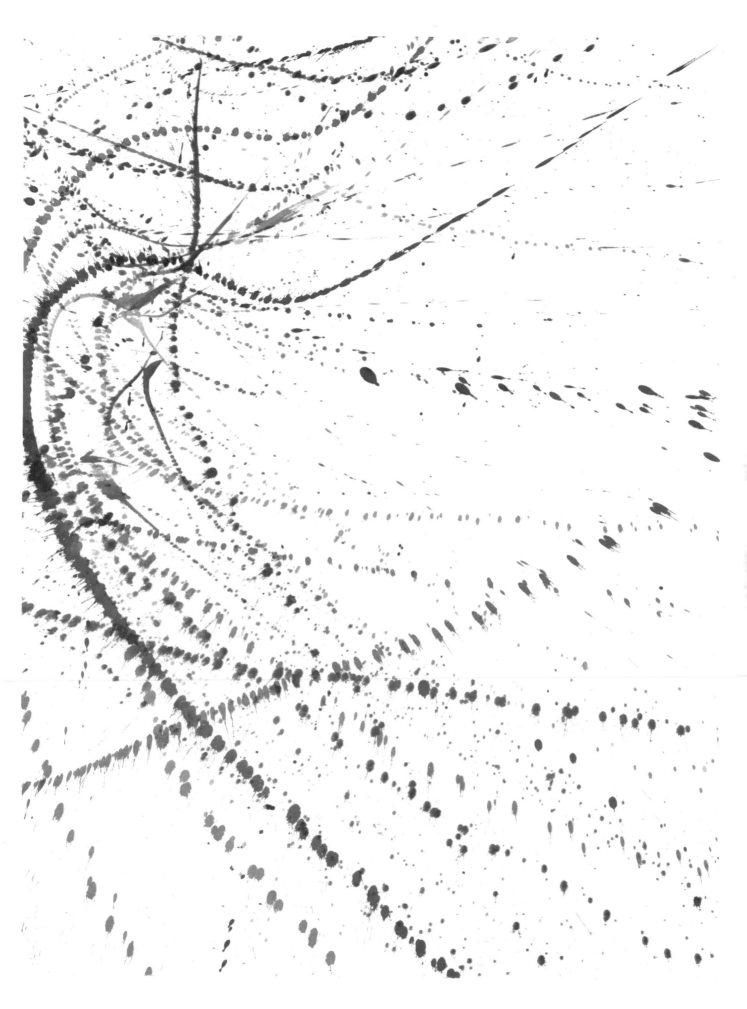

The following illustrations show clearly how, with the use of stencils, positive and negative results can be achieved.

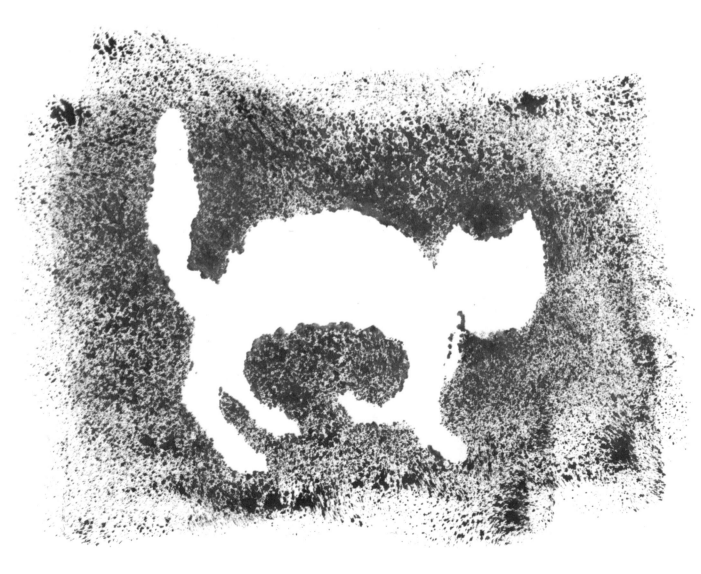

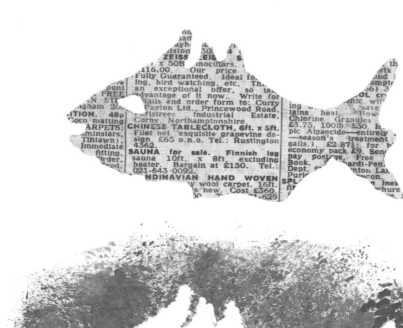

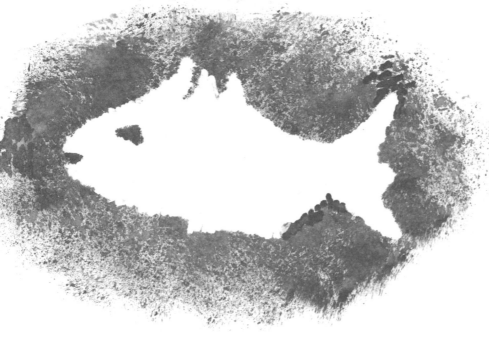

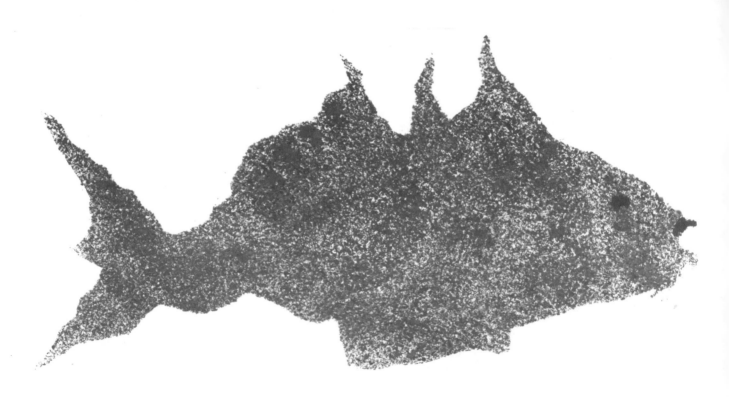

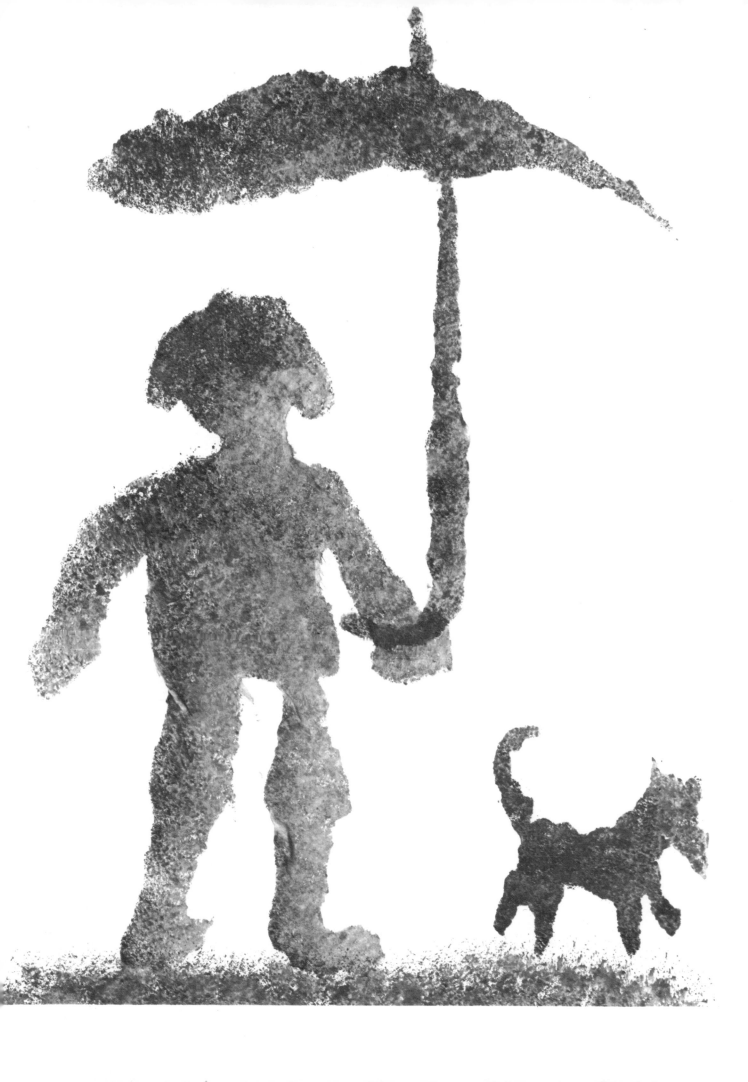

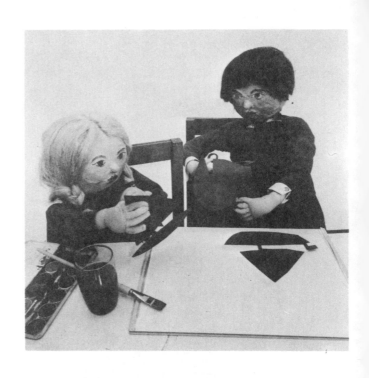

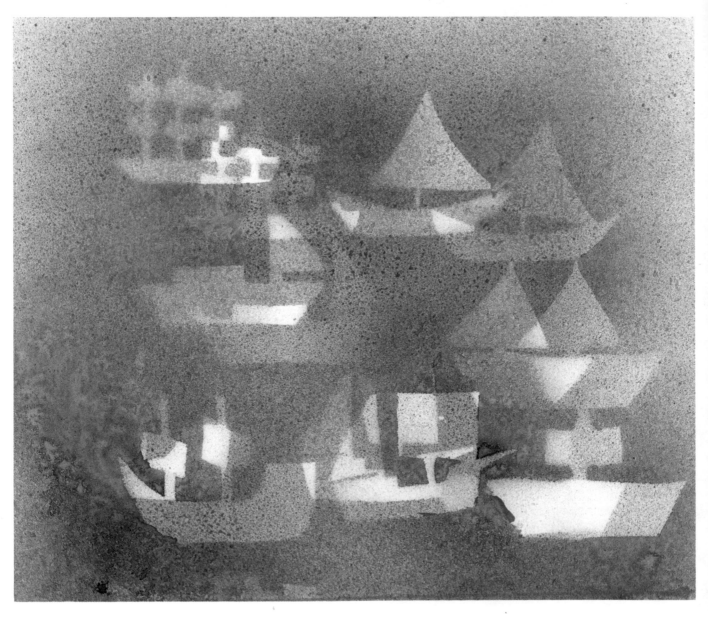

Potato cuts

Potato cuts are always a great favourite with children. They are so easy to manage and can be used many times. This form of printing is of course ideal for pattern making where a large number of repeats are required. Corks make good prints too.

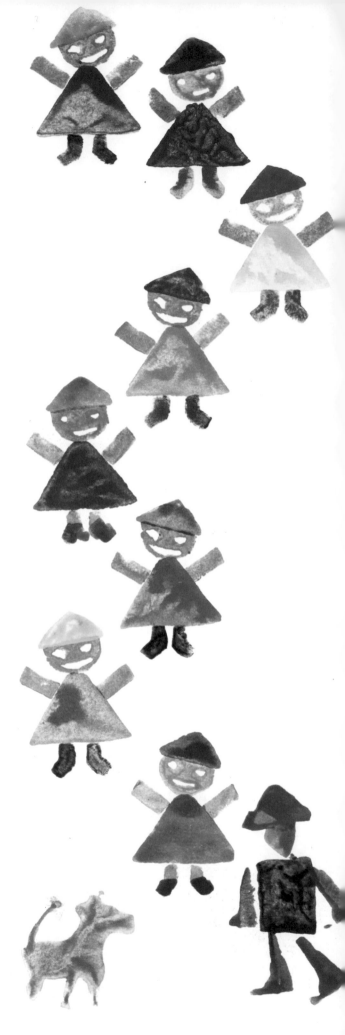

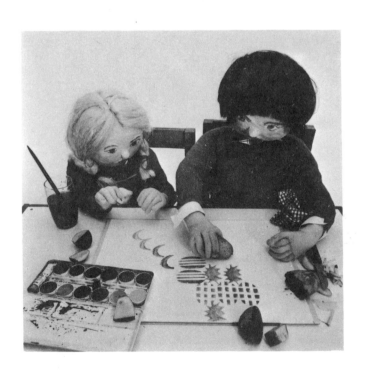

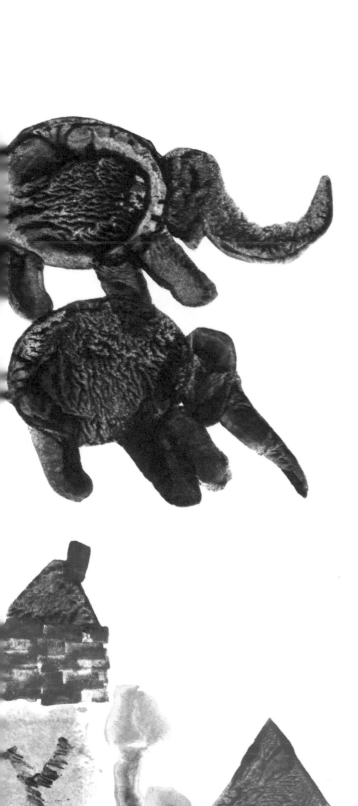

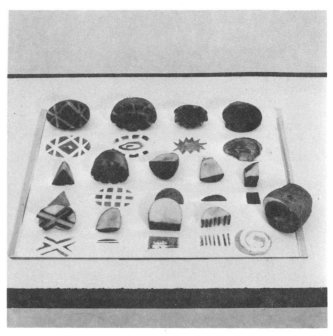

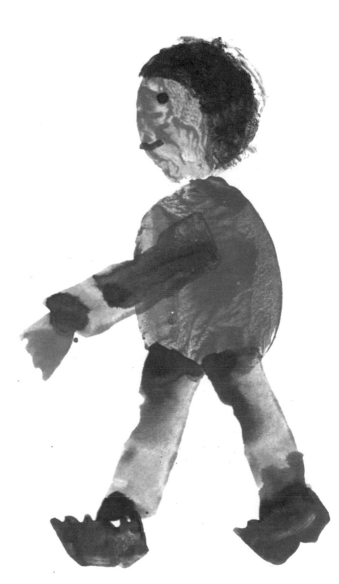

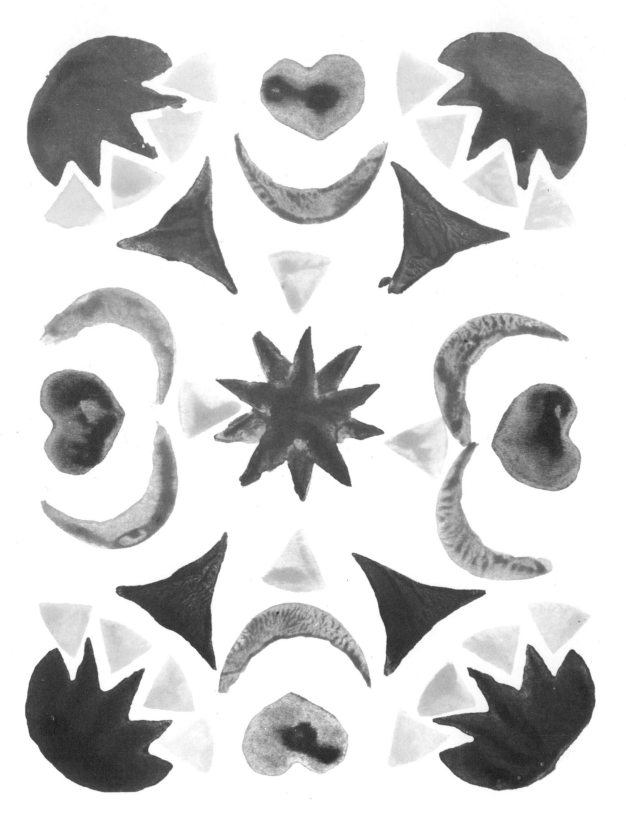

The same principle can be applied to other
vegetables such as the cauliflower, onions
and cabbage used in the composition below.

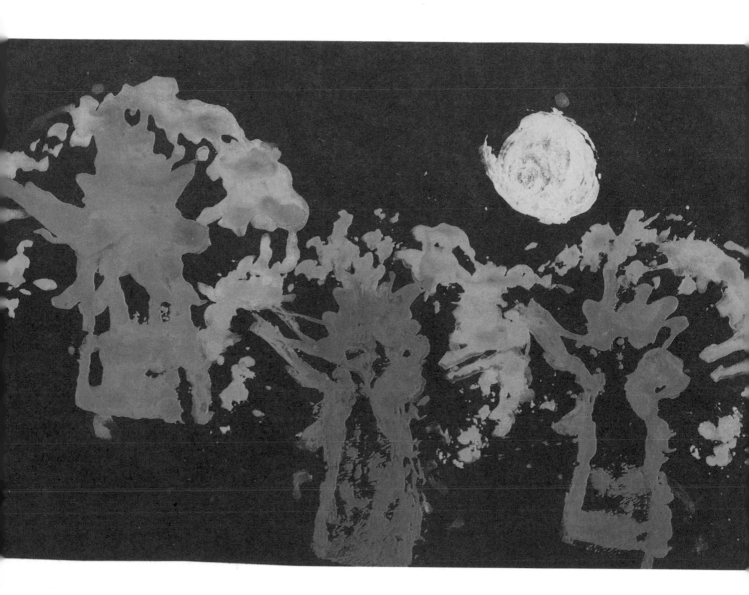

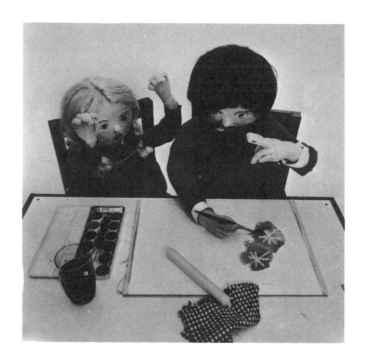

Whenever possible children should be allowed to display their work either in the classroom or in their bedroom.

Wax paintings

Wax paintings give children a great deal of pleasure. They delight in the mysterious way that a picture can be revealed by brushing a thin coat of water colour over white paper on which a drawing has been made with a white candle.

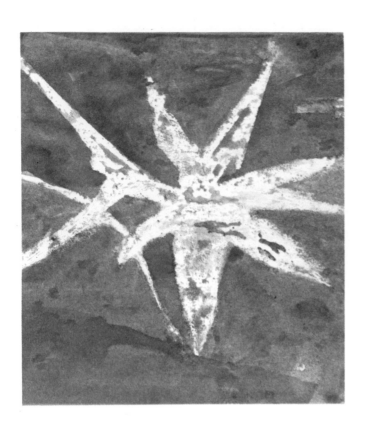

This technique can be developed in several colours starting with the lightest shade. It is, however, important to allow the paint to dry between each candle drawing.

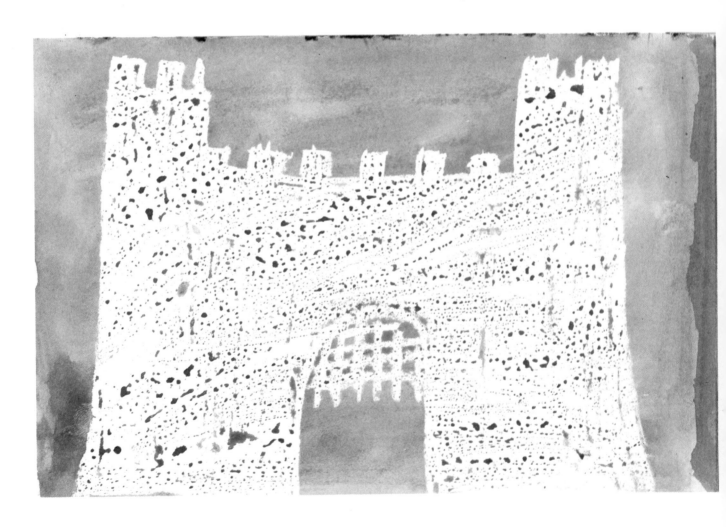

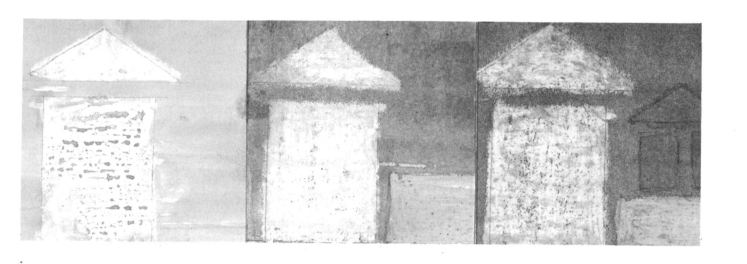

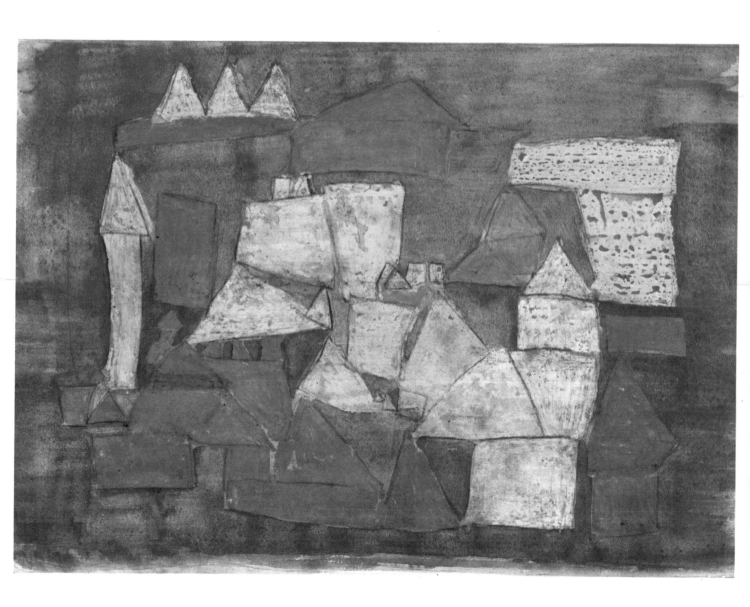

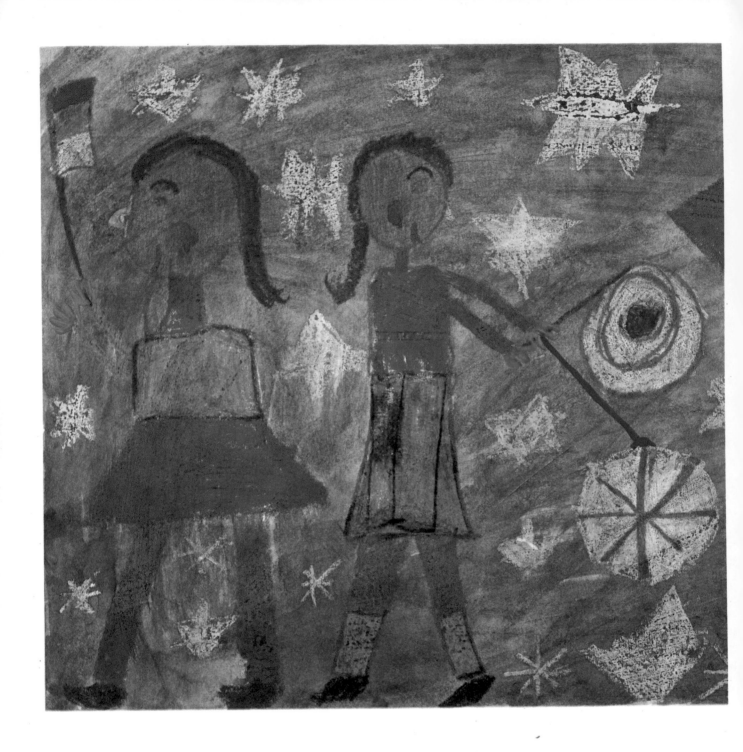

Crayons and paint
The principle that paint will not adhere to a wax surface is tried out, using crayons. Here with different colours it is possible to see better what is being drawn. The picture can then be painted over, the coloured crayon work showing up brightly.

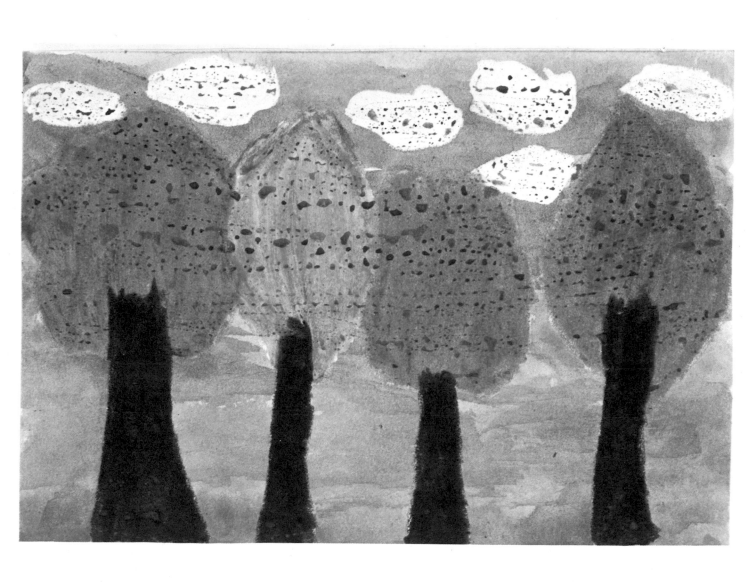

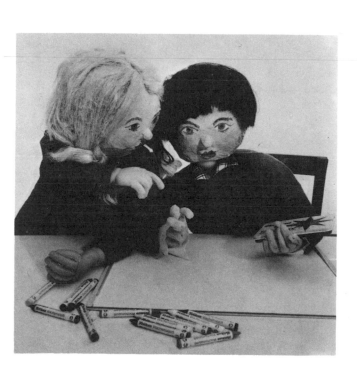

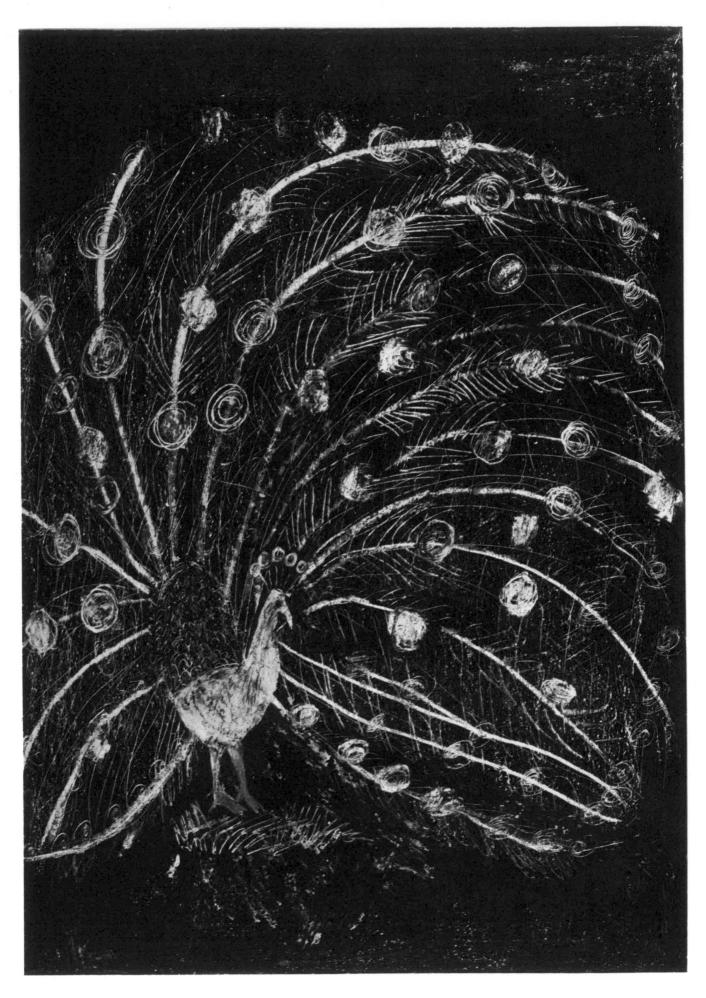

Scraped crayons—Sgraffito
All sorts of experiments with crayons should be encouraged. A drawing made in very thick bright colours is covered completely with black crayon. Then, using a small scraper or penknife the black is scraped away to make a picture. The peacock and the fish are fine examples of the imaginative use of this technique.

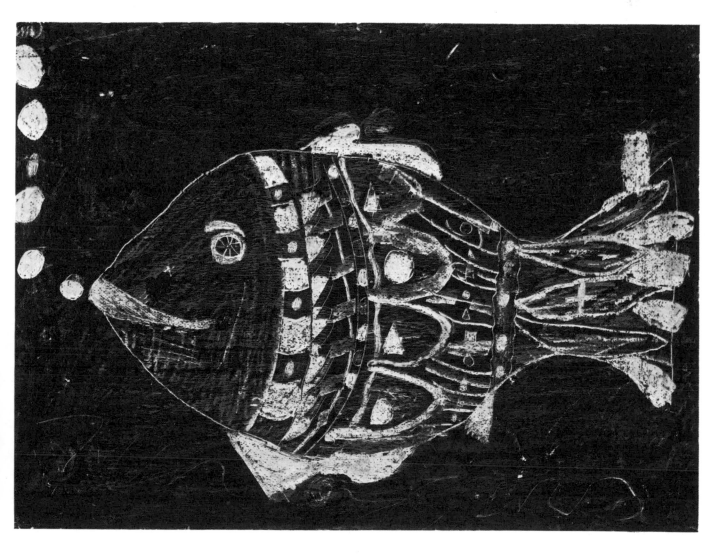

Crayons tend to flake when used heavily. The 'crumbs' can be cleaned very easily away with turpentine on a rag. Turpentine dissolves the wax crayon—and can of course dissolve the picture as well! However, when used carefully on a brush an interesting technique is discovered. The turpentine changes the texture of the drawing producing an attractive translucent effect, rather like a water-colour painting.

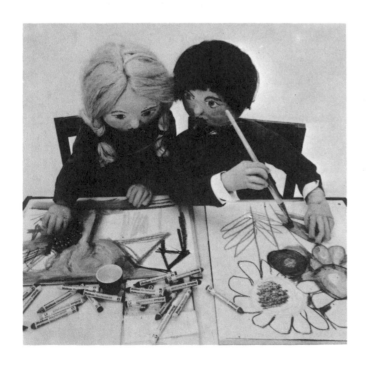

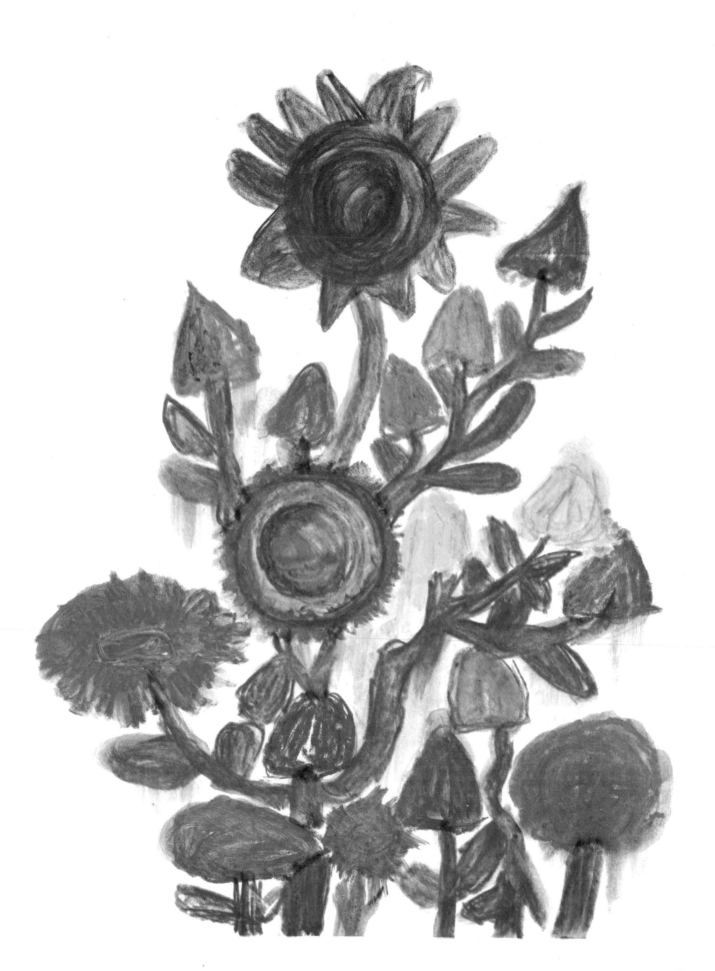

Mixing reds
A collection of fruits such as tomatoes, red peppers and radishes show clearly that there are many shades of red.

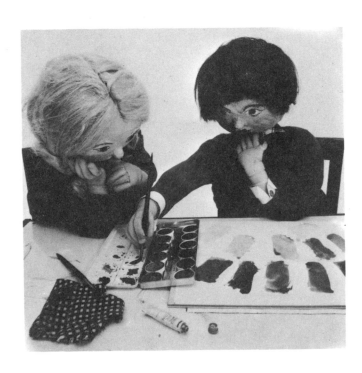

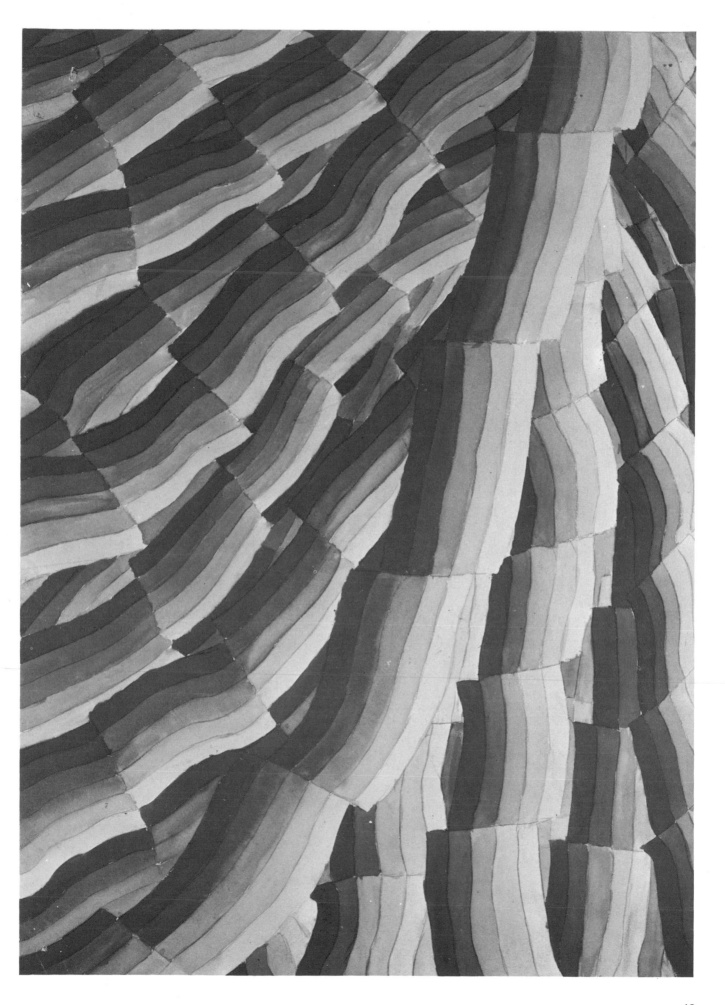

By mixing different colours with red, such as
red and yellow, red and ochre, red and white,
red and blue, red and black, a large number
of shades can be made.

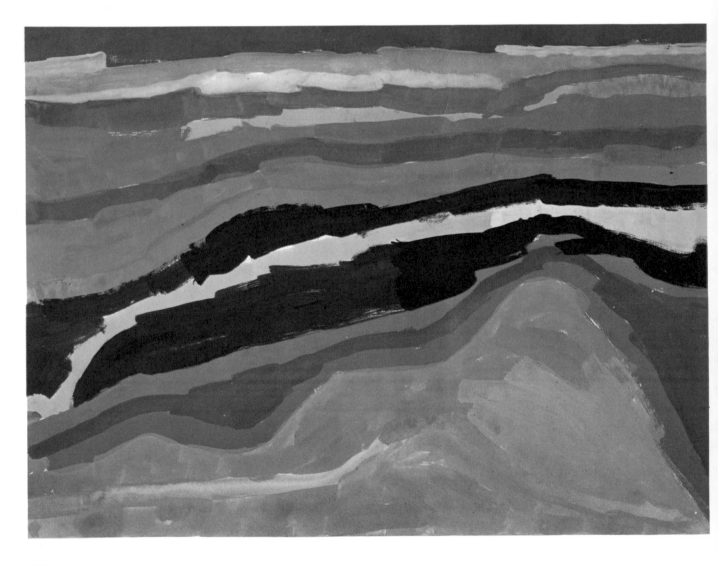

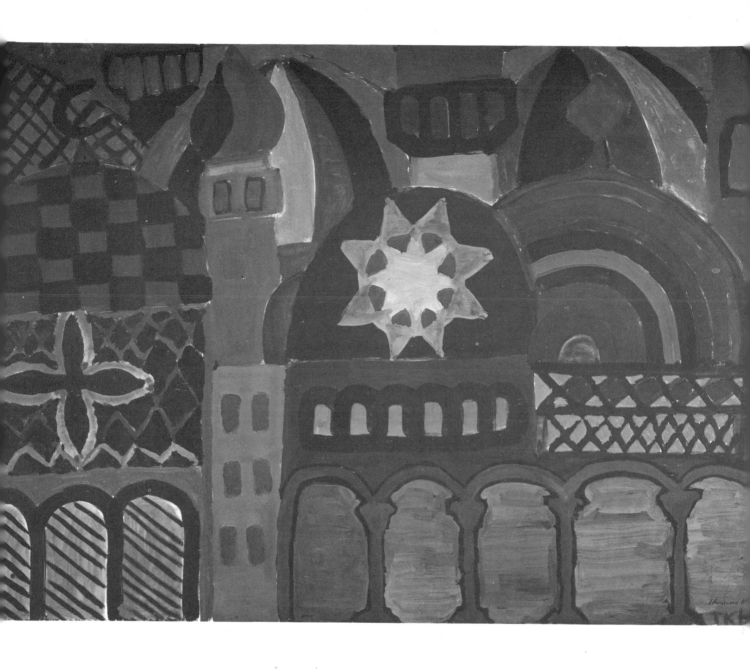

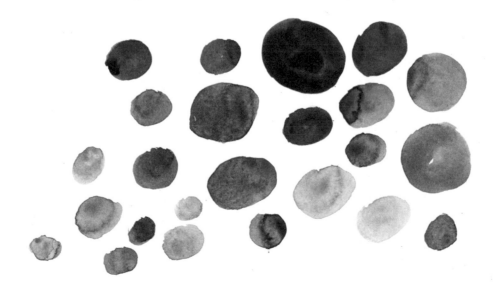

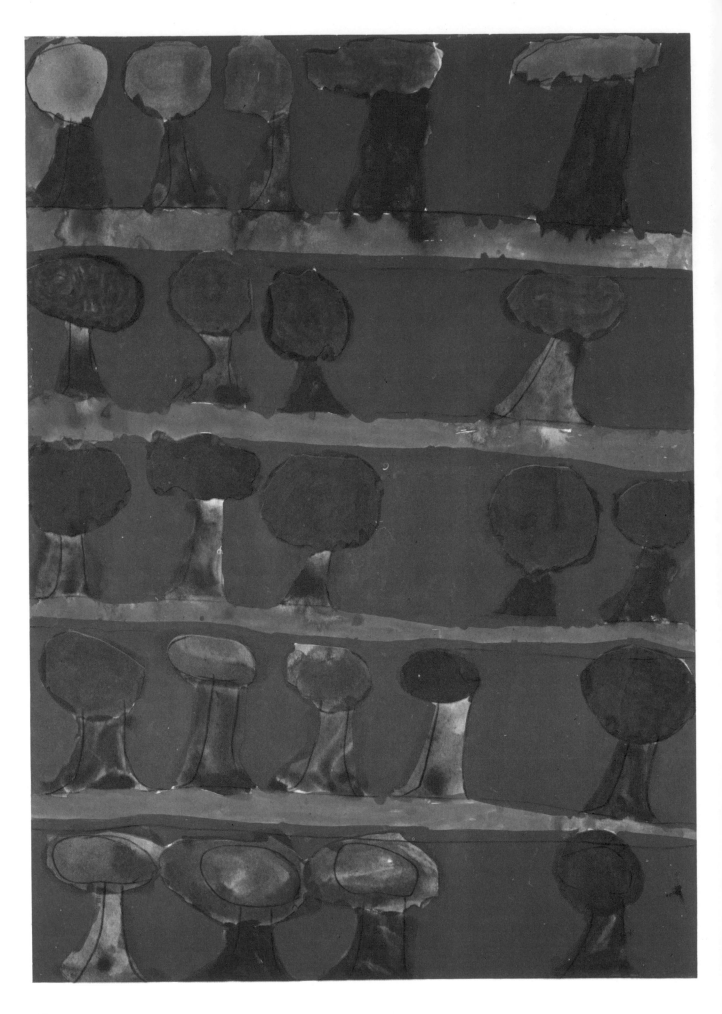

Mixing greens
By the same principle all sorts of shades are obtained.

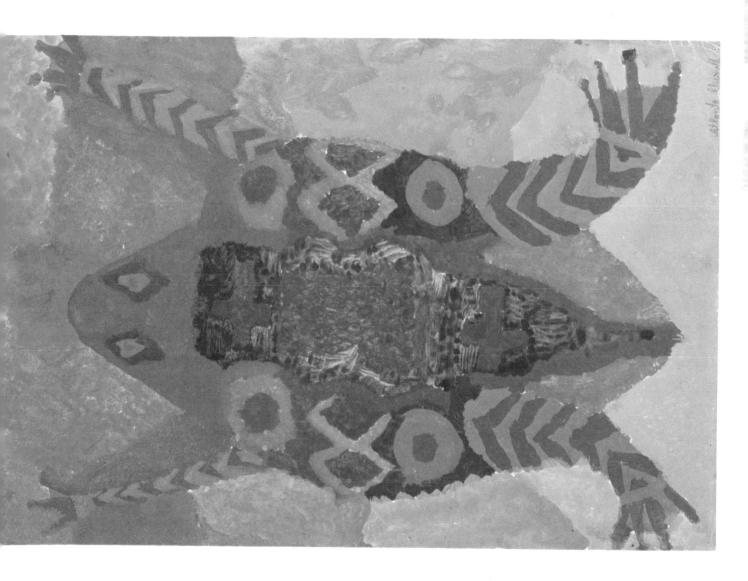

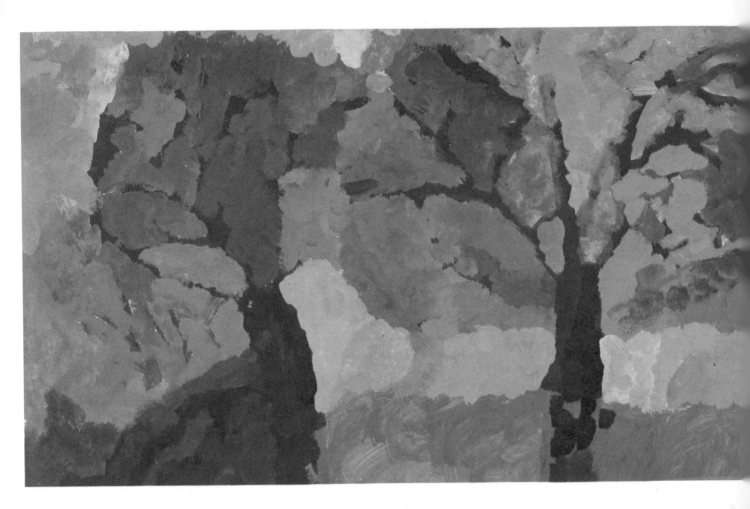

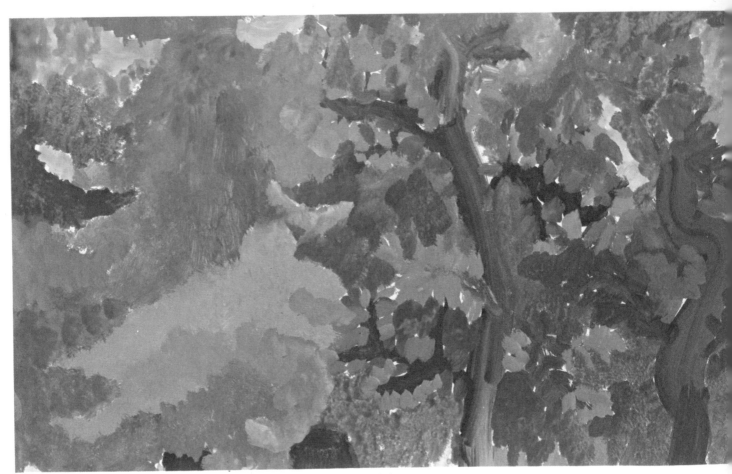

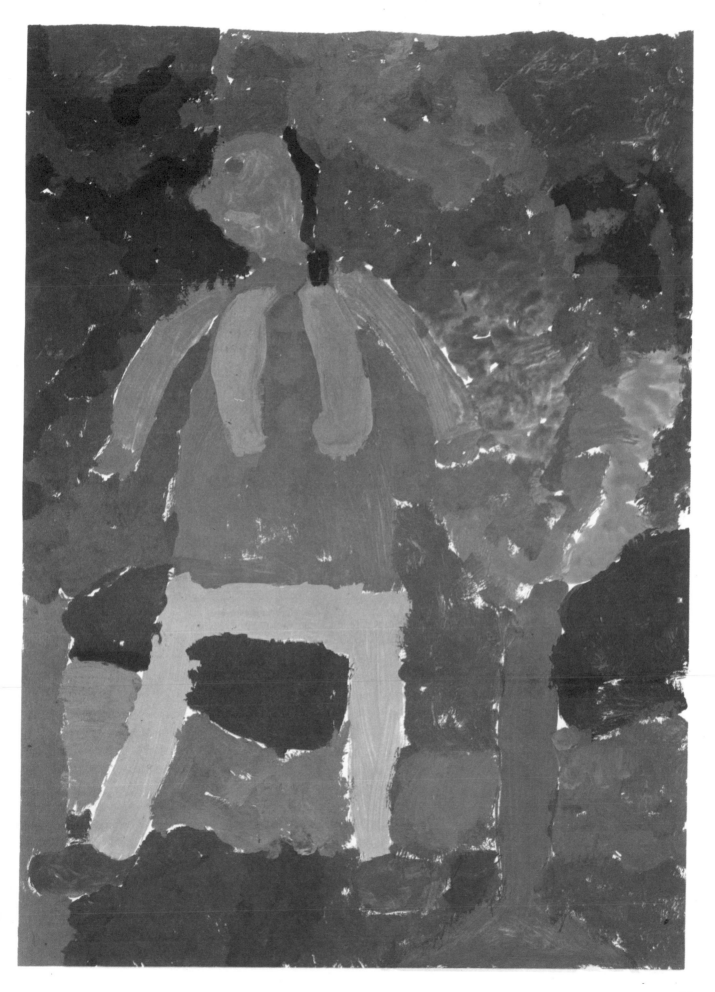

49

Warm colours
Sun and fire are yellow and red. Therefore
red and yellow are called warm colours.

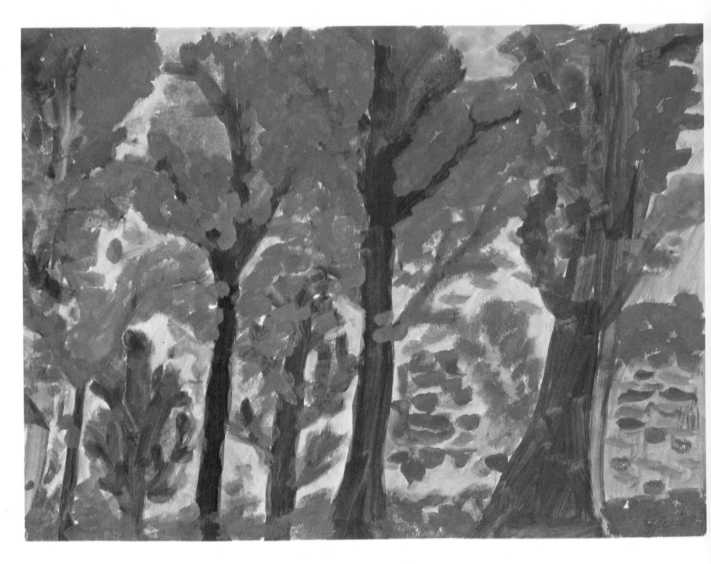

Cold colours

Water and ice are blue and green. So blue
and green are called cold colours.

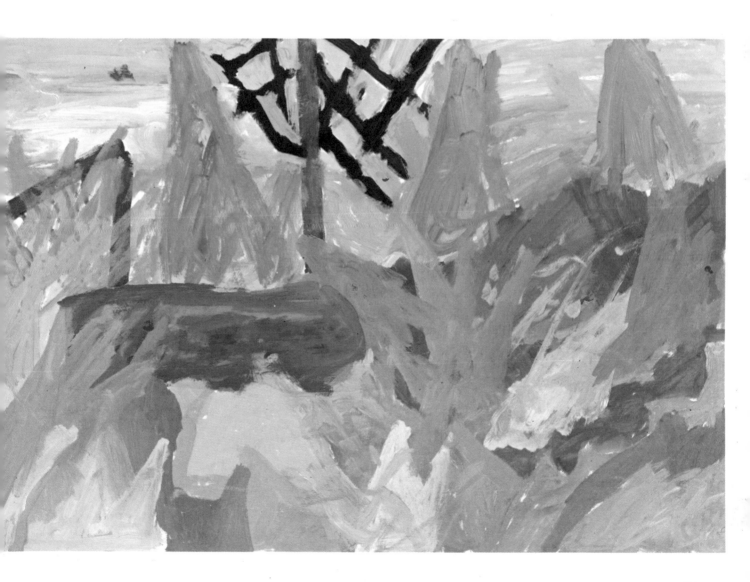

Warm colours can be cooled by mixing them with cold ones. That means yellow with green, or red with blue. The two new colours made are colder than yellow and red. Green can be made colder by mixing it with blue.
Cold colours can be made warmer by mixing them with yellow and red. All colours can be brightened with white, or darkened with black.

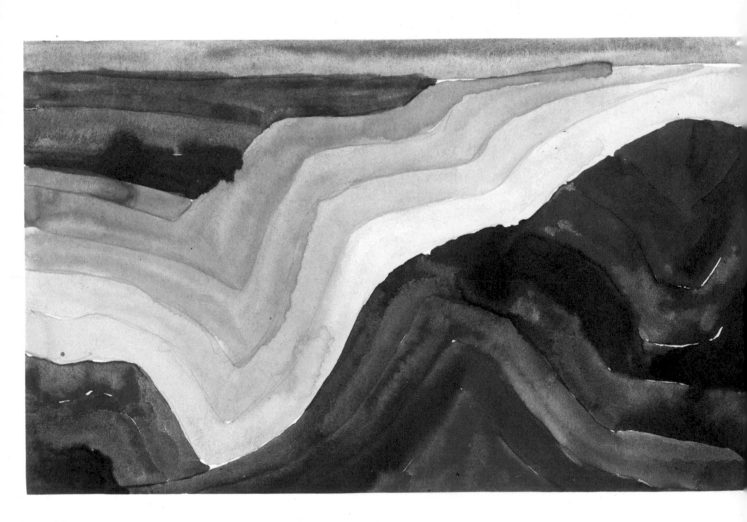

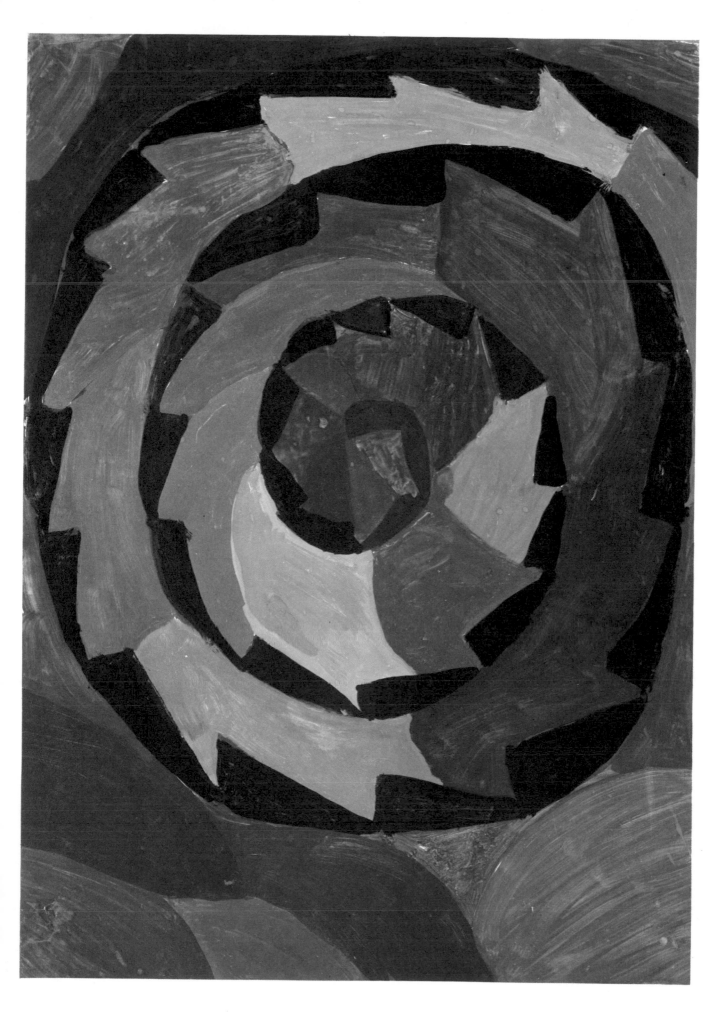

Black and white may not in themselves be
very interesting but when black is mixed with
white many different shades of grey appear.

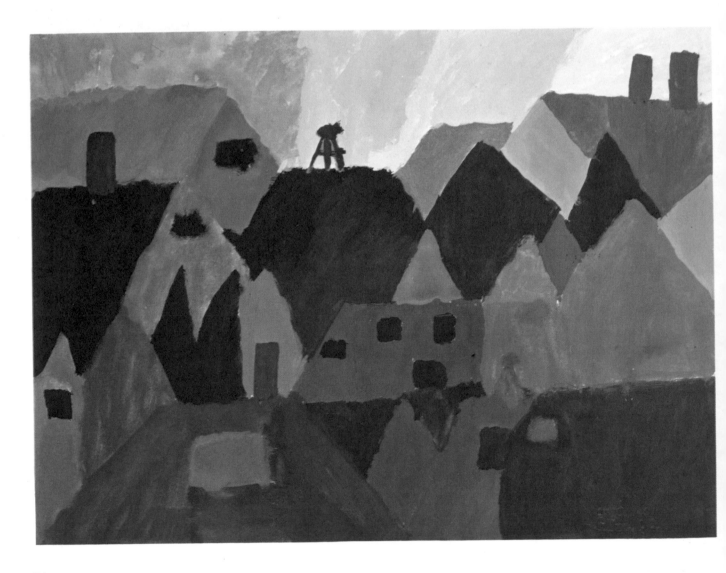

An interesting and colourful composition using the symbolic house shapes.

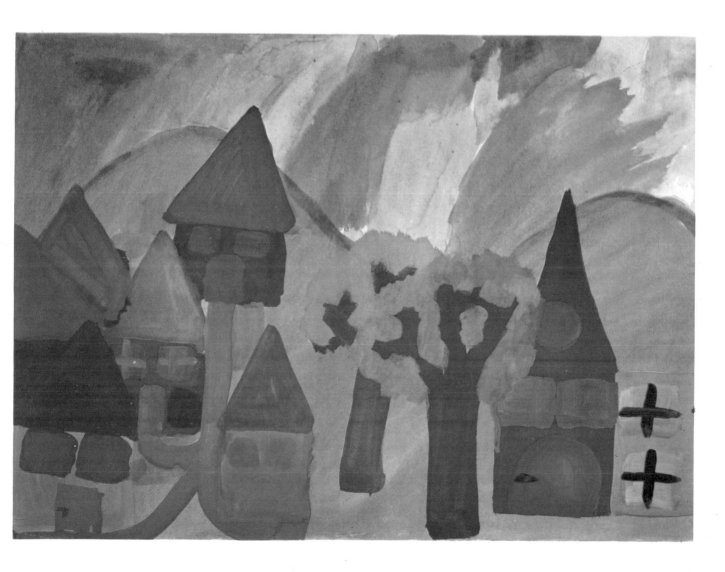

Paste paper paintings

This technique is ideal for making gift-wrap paper. All that is required is large sheets of paper, a brush, paints, pieces of cardboard, a pair of scissors and adhesive such as *Margros*. The paper is covered with glue and painted. Then with a finger, brush handle or piece of cardboard, patterns can be traced over the sheet. All kinds of exciting designs can be made.

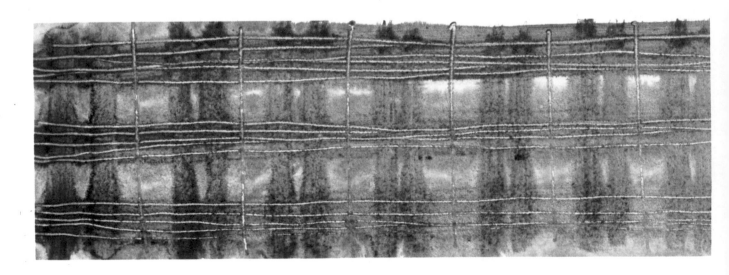

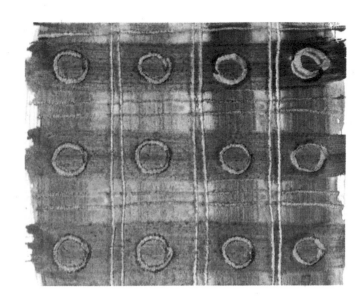

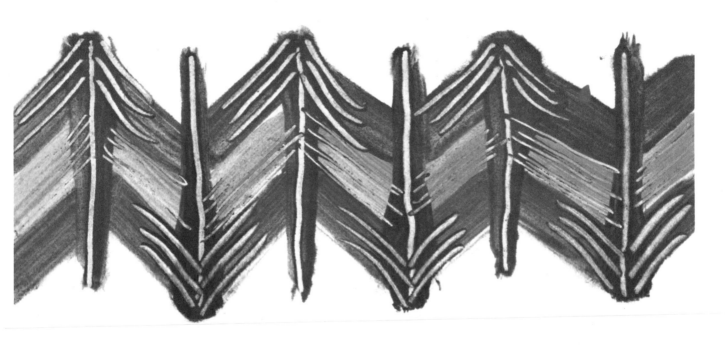

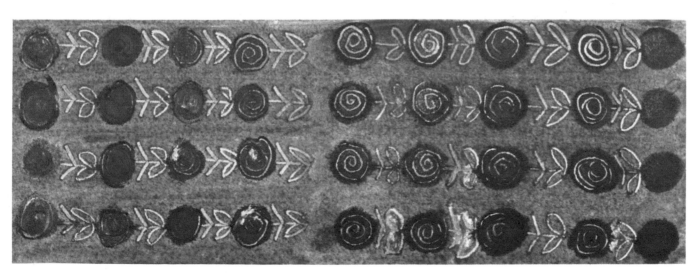

A similar technique was used to produce these two attractive puppet paintings.

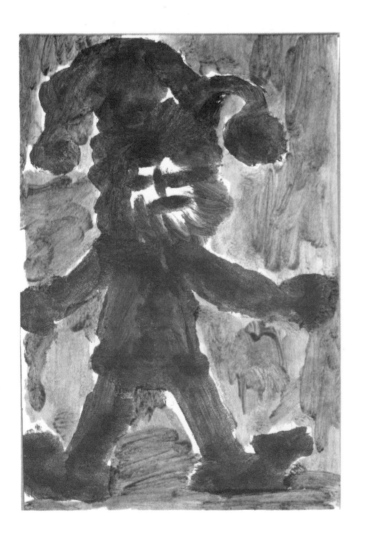 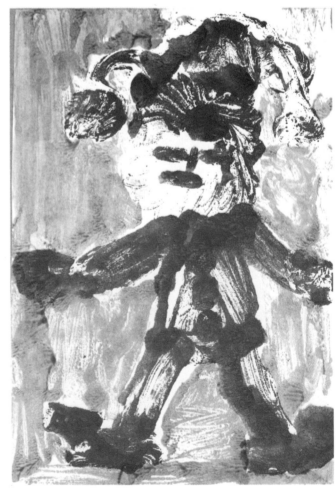

Another idea for gift-wrapping.

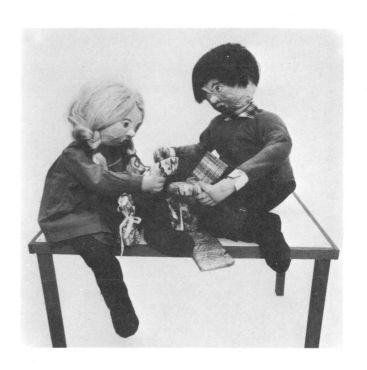

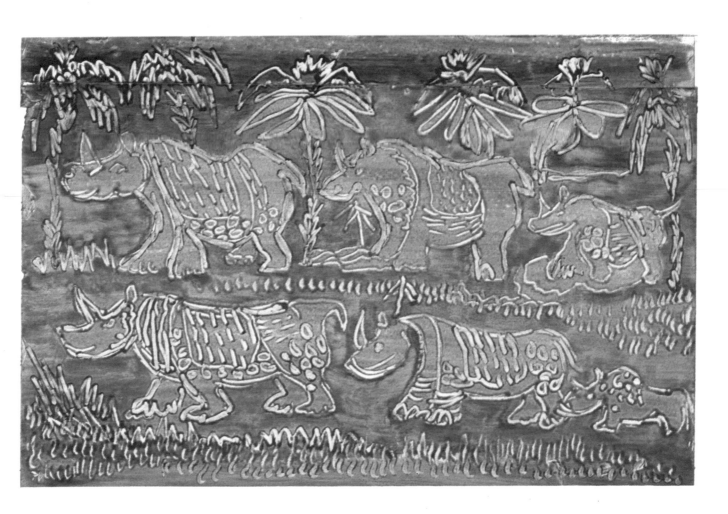

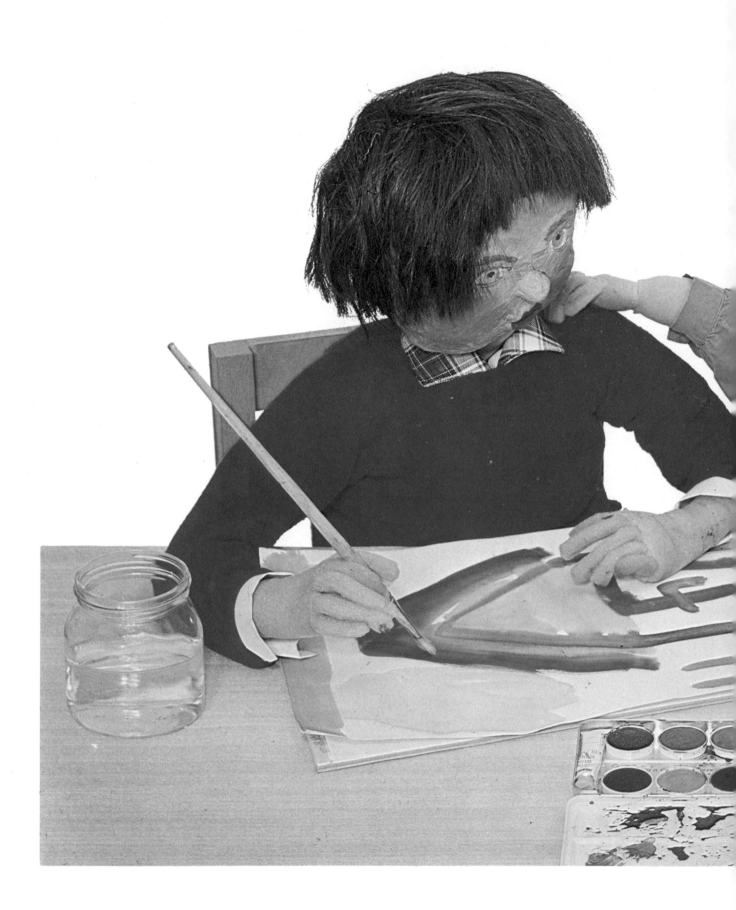

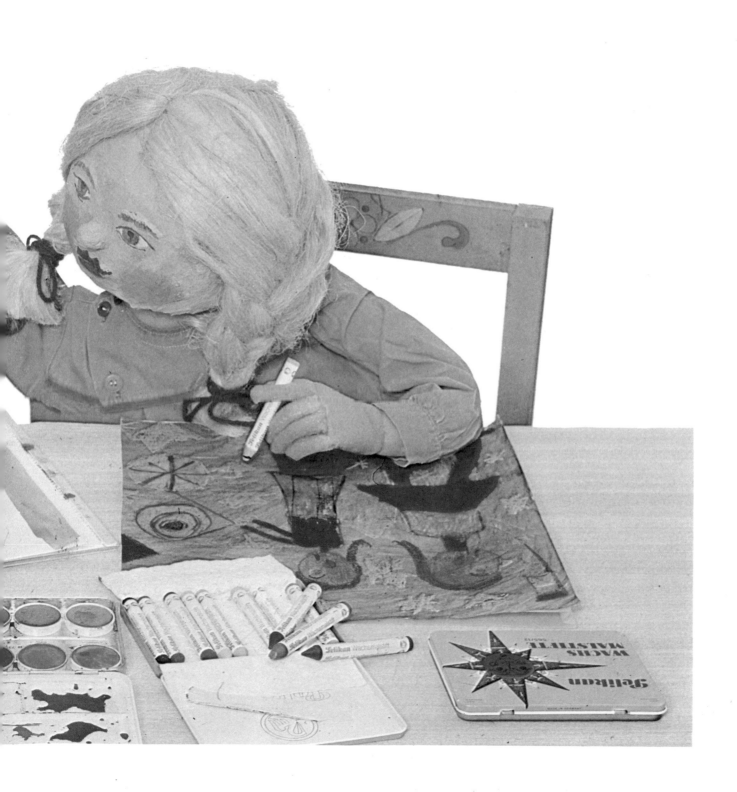